MONTANA STATE UNIVERSITY - BOZEMAN
LIBRARY

D0764856

Telling Histories

INSTALLATIONS BY ELLEN ROTHENBERG AND CARRIE MAE WEEMS

Catalogue and Exhibition by Mary Drach McInnes

Boston University Art Gallery

UNIVERSITY OF WASHINGTON PRESS ❏ SEATTLE AND LONDON

Boston University Art Gallery
855 Commonwealth Avenue
Boston, Massachusetts 02215

© 1999 by Trustees of Boston University
All rights reserved.
"Telling Histories: Installations by Carrie Mae Weems and Ellen Rothenberg,"
by Mary Drach McInnes, © 1999 by Mary Drach McInnes.
All rights reserved.

Ritual and Revolution, © 1999 by Carrie Mae Weems
All rights reserved.

Distributed by the University of Washington Press
P.O. Box 50096, Seattle, Washington 98145

Printed in the United States of America
Library of Congress Catalogue Card Number: 99-73614
ISBN: 1-881450-11-2

COVER ILLUSTRATION:
Top: Detail, Carrie Mae Weems, installation view, *Ritual & Revolution,* 1998.
Bottom: Detail, Ellen Rothenberg, installation view, *Beautiful Youth,* 1995–99.

AL
16557
R67
A4
1999

Contents

The quest for memory is the search for one's history.

—Pierre Nora, "Between Memory and History: *Les Lieux de Mémoire*"

Acknowledgments

I would like to thank Ellen Rothenberg and Carrie Mae Weems for making this exhibition and catalogue possible. Not only have they created artwork that engages us in the exploration of history's construction, use, and promulgation, but they have done so in an aesthetically exhilarating manner. Both artists worked further to configure their installations specifically for the Boston University Art Gallery. At every step in the organization and realization of *Telling Histories,* they have been generous with their time, insights, and guidance.

I would also like to acknowledge the contributions made by P•P•O•W in New York and the Rhona Hoffman Gallery in Chicago which represent Ms. Weems. These galleries have played a significant role in supporting installation work in general and have assisted with many of the details involved in bringing *Telling Histories* to fruition. *Beautiful Youth* will be exhibited at the Vedanta Gallery, Chicago, in February 2000.

The Boston University Art Gallery has enjoyed the assistance of a number of grants that have made this exhibition and catalogue possible. I would like to thank Boston University professor Katherine T. O'Connor and the Humanities Foundation of the College of Arts and Sciences, and the Graduate School, for support of the catalogue. I also thank the LEF Foundation for providing the project with seed money and for underwriting the installation. And I would like to express gratitude to Alfred University for providing Mary Drach McInnes with a faculty summer research grant for curatorial travel.

This exhibition emerged from a seminar that Professor McInnes taught in spring 1997 in the Department of Art History at Boston University. I wish to extend my thanks to all of the students who participated in that class and who provided a forum in which the ideas that informed *Telling Histories* were greatly refined. The participants included Scott Alberg, Frances Altvater, Allison Brown, Charlotte Connors, Kathryn Delmez, Jacob Garver, Jennifer Jensen, Yumi Lee, Jill Levinsky, Sydelle Rubin, Lisa Weintraub, and Eric Wolin. I want to thank Mary Drach McInnes for agreeing to see the exhibition through to completion. Both the class and the exhibition result from a long and fruitful relationship between her, the gallery, and Boston University.

The Art Gallery staff has worked diligently on this project, and I am particularly grateful to Curator Karen Haas for the care with which she has edited the essays in this catalogue. I further want to single out the efforts of Preparators Christopher McEvoy and Gabriel Phipps, who worked with such dedication on Rothenberg's *Beautiful Youth.* I also thank Julie Marchenko, Catherine Blais, Michelle Lamunière, Wendy Stein, Andrew Tosiello, Rachel Hyman, and Francesca Tronchin.

John R. Stomberg
Director

Introduction

Telling Histories presents recent installations by two artists—Ellen Rothenberg and Carrie Mae Weems—whose work examines the nature of memory and history. Their art constructs new critical narratives that reclaim "woman" and her story. Each installation evokes the female body as interrogator of and accomplice to history.

Ellen Rothenberg compiles real and fictive "documents" to recreate lost historical narratives. In her work, Rothenberg collects, manufactures, and manipulates everyday objects that were in circulation during the period that she is investigating. In *Beautiful Youth* (1995–99) she explores the construction of feminine identity during the Third Reich. The artist radically manipulates propaganda photographs of the mandatory work organizations for women in the 1930s and 1940s. Rusted steel frames the portraits of Aryan youths; we see grainy images of women smiling, gathering berries, harvesting crops, feeding babies, churning butter. The images are accompanied by linen aprons and work tables filled with severed fingers and hands. These wax fragments speak to the fascist model of women's work and to its continued resonance in contemporary life.

The vastness of history and the ongoing struggle of disenfranchised people is the tale of Carrie Mae Weems's *Ritual and Revolution* (1998). This project consists of a series of translucent muslin banners digitally printed with photographic images ranging from an African slave port to a street demonstration in Alabama. *Ritual and Revolution* relies on the artist's own voice; Weems is a storyteller who participates in history with us as we walk through the installation. Her voice acts as witness:

> *From the four corners of the world*
> *I saw you bewildered, startled & stumbling*
> *toward the next century*
> *looking over your shoulder*
> *with fingers crossed*

Weems uses anecdote and biography to reclaim the "great moments" of history.

This exhibition emerges from recent interest in rethinking monuments, in reconstructing historical narratives, and in reshaping public memory. It builds on national and international debates concerning the nature of memory. Interest in exploring cultural amnesia is strong. Recent lectures (such as "Remaking History" at the DIA Art Foundation and "The Persistence of Memory" at Harvard University) and public exhibitions (such as *Distemper* at the Hirshhorn Museum and *New Histories* at Boston's Institute of Contemporary Art) attest to the particular urgency of this discussion for our audience.

The subject of memory has surfaced in the larger political arena as well. In Europe during the 1990s, we have seen Germany reunited, the Balkans break apart, and the reinvention of official memory in Russia. We continue to debate the representation of the Holocaust as both Axis powers and "neutral" Switzerland make reparations. Our current fascination—even obsession—with memory is

grounded in the inherent temporal linking of the past with our contemporary life. Memory is not dormant. It is present in our construction of race and gender, and it resonates through our current political discussions. This linkage informs and shapes much of recent art.

Contemporary artists have blurred the lines between history and memory. A number of provocative artists give physical form to the unofficial, hidden narratives. Many of these artists, like Weems and Rothenberg, are women who destabilize the patriarchal structure of history. One thinks of Doris Salcedo's marking of wounds on her furniture pieces that evoke the state of terrorism in her native Colombia; Kara Walker's cutting of silhouette forms that touch our collective memory of racist imagery; Zofia Kulik's imaginative use of photographic collage to explore and parody Poland's recent history of fascism; or Adriana Varajão's appropriation of Baroque ceramic decoration to point to the multiple layering of culture and the lasting impact of colonialism in Brazil. These artists are influenced by feminist ideas, postcolonial theory, and historic revisionism. Their intellectual discussions are joined by aesthetic concerns. Like many of their generation, these women are critical of modernism's "purity," and yet they are unburdened by postmodern debates regarding media, appropriation, or aesthetic vocabulary. Instead, they extend the hermetic borders of the art world to engage a broader political content.

Ellen Rothenberg and Carrie Mae Weems share similar aesthetic concerns and social commitments. In revisiting the past, these artists construct contemporary narratives of social importance. Formally compelling and morally provocative, their installations resist the master narrative of history and retrieve lost memories.

In presenting this exhibition, I am indebted to the generosity of both artists. To Ellen Rothenberg and Carrie Mae Weems, I offer my deepest gratitude for their participation on this project. Over the past several months, I have been rewarded by their humor and insight, their energy and dedication.

I am grateful to a number of my colleagues in the academic community for their help. In particular, I would like to thank Richard Thompson, Dean of the School of Art and Design, the New York State College of Ceramics at Alfred University, for giving me time to write this catalogue. I would also like to acknowledge the staff at the Samuel R. Scholes Library who were extremely helpful in aiding my research, especially Elizabeth Gulacsy. The issues presented in the catalogue were explored in a number of seminars given at both Boston University and Alfred University, and I thank all of my students who participated in these discussions.

Finally, I would like to thank my readers for their comments: Martha Anderson, Deborah Martin Kao, Marion Kaighn McInnes, and Carlos Dieter Szembek. To Andrew McInnes—as always—my deepest thanks for his familial and critical support.

Mary Drach McInnes
Alfred, New York

Telling Histories

INSTALLATIONS BY ELLEN ROTHENBERG AND CARRIE MAE WEEMS

Oh Sophie, darlin', you say "History" but that means nothing. So many lives, so many destinies, so many tracks go into the making of our unique path. You dare say History, but I say histories, *stories*. The one you take for the master stem of our manioc is but one stem among many others....

— Patrick Chamoiseau
Texaco (translated from
French and Creole)

The contemporary interest in interrogating, resisting, and manipulating history is witnessed in Ellen Rothenberg and Carrie Mae Weems's recent installations. Rothenberg's *Beautiful Youth* (1995–99) and Weems's *Ritual and Revolution* (1998) decenter the singular text of "History" and create new stories. Their narratives are not dry history lessons, but rich evocations in personal voice. In telling these histories, both artists incorporate many of the elements associated with history's doppelgänger—memory. Like memory, their art is supple. Their meanings are elusive, their narratives open-ended, their information malleable.

Weems and Rothenberg appropriate images and gather objects that draw on our collective memory and lead us into a rich dialogue with history. In walking through their installations, we jump across borders and leap through time. Judith Wilson wrote of this kind of transcultural conversation: "Instead of the spiraling downspout of history, memory and desire hopscotch from point to point, across vast distances, to form an elaborate network of continuous exchanges."[1] In these performative works, Weems and Rothenberg offer a redaction of the official story of events. These two artists participate in the general unmasking of what is known as the "master narrative" of history, the story of the victor rather than the conquered.

The field of historical inquiry, a discipline that reaches back to the Enlightenment, has increasingly come under attack as patriarchal and Eurocentric. Many contemporary authors, including novelist Patrick Chamoiseau, offer alternatives to the tradition of monolithic world history. Chamoiseau's organic and multibranched "histories" subvert the master narrative. This literary assault is matched by recent academic treatises. Time-honored premises such as "objectivity" and "consensus" are now questioned. Further, there is a general challenge to the "ideal" historian as an

impartial observer. Plainly stated, there is a sense of disarray in the field. [2] The attack comes from within the discipline as well as without. Eminent scholars, such as Lawrence Levine, urge historians to continue "complicating simple pictures, finding intricacies where before we had certainties, turning unity into multiplicity, clarity into ambiquity," and feminist historian Joan Wallach Scott critiques the master narrative as "not only incomplete but impossible of completion in the terms it has been written." [3] This reclassification of history occurs at the intersection of multiculturalism, postcolonial theory, and feminist criticism. In place of the singular version of history, countless stories are

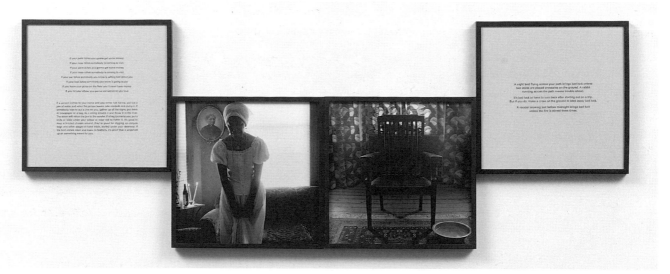

FIGURE 1
Carrie Mae Weems
Untitled [Woman in White/Pan of Water], *Sea Islands Series,* 1992
2 silver prints; 2 text panels each 20 x 20 inches; overall 30 x 80 inches

emerging—stories drawn from women, diverse classes, and the Third World. These are the voices traditionally silenced by the master narrative. The current remaking of history accompanies an awareness of its importance in our everyday lives: it shapes our political discussions and resonates in our personal explorations of identity.

Carrie Mae Weems vigorously examines the race wounds of our history and skillfully engages feminist issues. [4] In her *Sea Islands Series* (1992), Weems recovers the lost slave culture of the Gullah Islands of Georgia and the Carolinas. In one multi-panel work, she presents herself as a slave (figure 1).[5] She stands in a parlor dressed in white, her head bowed, her eyes downcast and her hands clasped at the groin; she assumes a position of pain. Next to this self-portrait is a photograph of a chair with a basin of water at its foot. The emptiness of the chair and basin are evocative of the absent sitter. Bracketing these two images are text panels that convey folk sayings, fortune telling, and home remedies to assure good luck. A sampling of these sayings includes:

> If your palm itches you gonna get some money.
> If your nose itches somebody is coming to visit.
>
> If a person comes to your home and you sense bad karma, put out a
> pan of water and when the person leaves, take it outside and dump it. If

somebody tries to put a jinx on you, gather up all the signs, put them
in a newspaper or bag, tie a string around it and throw it in the river.

A rooster crowing just before midnight brings bad luck
unless the fire is stirred three times.

Weems's slave is physically bound by these instructions—superstitions that create the texture of slave life.[6] Weems portrays woman as the carrier of culture; it is she who inherits and practices the lessons of her ancestors. For Weems, history is embodied in this figure of the slave, whose legacy is physical as well as emotional. In a concurrent project, the artist addresses notions of heritage through text printed on ceramic dishes:

WENT LOOKING FOR AFRICA

and found it
tightly woven in a woman's hair

The heritage of the slave culture is not only found in folk remedies and voodoo incantations, but in the body of the slave herself.

The epic of history is being supplemented by diaries, testimonies, and oral histories. This interest in the subjective, personal face of history has blurred the lines between genres. The barriers between historical "fact" and narrative "fiction" have fallen rapidly. In a recent book review, novelist and biographer Peter Ackroyd addresses this contemporary ambiguity:

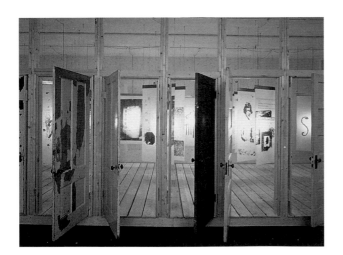

FIGURE 2
Ellen Rothenberg
installation view
Partial Index, 1991
mixed media

In novels one is forced to tell the truth, for example, whereas in biography one can invent more freely. This will sound like a paradox only to those who do not practice either art. In fiction the accuracy and coherence of the imaginative narrative must be strong enough to impart a vision of truth to the reader; in biography the devices and tricks of historical narrative are so abundant that it is much easier to disguise lack of knowledge or loss of comprehension. Biography is the art of concealment; fiction is that of revelation.[7]

The breakdown of the literary genres is just one indication of the growing consensus on the malleability and plurality of history.

Ellen Rothenberg has used the diary of Anne Frank as the basis to question how we know and construct history. Her three-part *Anne Frank Project* (1990–1994) extends and transforms our knowledge of the young Jewish girl whose diary is one of the central texts of the Holocaust. Rothenberg uses this diary as a springboard to engage issues of documentation.[8] In *Partial Index* (1991), the artist creates a forty-foot wooden room that acts "like a giant, architectonic filing cabinet"

FIGURE 3
Ellen Rothenberg
detail of installation
Partial Index, 1991
mixed media

(figure 2). [9] At one end is a bookcase papered with school photographs of Anne and her sister taken between 1935 and 1942; it contains a series of lead-jacketed telephone books marked with alphabetical tags (figure 3). Inside this room is an archive of actual documents of Anne Frank's life—pages from her diary, an analysis of her handwriting, floor plans of her hideaway—along with "false artifacts" that the artist has constructed. These fabrications include a monogrammed handkerchief, an undershirt, a radio—items that an adolescent at this time might have owned. Here, we examine and sense the body of Anne Frank in a variety of ways. Her identity remains elusive as "fact" and "fiction" merge. Meaning in Rothenberg's work is always open-ended: "I have an interest in making work that resists a singular or static reading, work that operates on different levels simultaneously, that requires a re-viewing.... Meaning is rarely resolved within a single object, a single action or a single image, but derives instead from an additive associative resonance." [10] This cumulative reading enriches our understanding of history.

A key factor in the revision of history is the incorporation of memory. At first, this critical engagement would seem peculiar, even aberrant. In traditional intellectual constructions, memory sharply opposes history. In place of historical fact, memory is ephemeral; in opposition to history's singular narrative, memory is polymorphic; in contrast to historical objectivity, memory is subjective. Yet this division is collapsing. As Natalie Zemon Davis and Randolph Starn argue, memory's organic flow now merges with the "historian's more or less calculated accounts of the past." [11] Increasingly, both memory and history appear to be heavily constructed narratives that serve our broad cultural and institutional needs. Instead of emphasizing the opposition between history and memory, many contemporary writers and artists highlight their interdependence. They use both history and memory to help us negotiate the past, understand the present, and map the future.

The intersection of history and memory is seen in contemporary "*lieux de mémoire*"—sites of memory. These locales, according to French historian Pierre Nora, embrace geographic places, personal testimonies, and scholarly treatises. They are various: sculptural monuments, literary confessions, anthropological records. Here, memories "converge, condense, conflict, and define relationships between past, present, and future." [12] For Nora, *lieux de mémoire* are situations where memory "crystallizes and secretes itself." [13] Yet as these sites remind us of past encounters, they are mere remnants of our once-great collective memory. Modern memory is but a trace of the vitality and immediacy of traditional memory.

Nora's writings on memory have a sense of urgency. *Lieux de mémoire* emerge at the very moment when we must consciously construct our memories or face losing them. History's over-powering of memory is relentless. Contemporary sites of memory mark a particular locus where history has supplanted and will eventually annihilate memory. The critical interrogation of the past that marks the discipline of history is antithetical, and for Nora, inherently destructive to the tradition of memory. *Lieux de mémoire* originate because our collective memory is at risk. As Nora states: "We speak so much of memory because there is so little of it left." [14] Consequently "we must deliberately create archives, maintain anniversaries, organize celebrations, pronounce eulogies, and notarize bills because such activities no longer occur naturally." [15]

The tension between the amnesia that grips our culture and our growing interest in witnessing history has prompted stimulating intellectual debate and great imaginative discourse. [16] The production of these memory sites may take many forms. Mieke Bal writes: "The memorial presence of the past takes many forms and serves many purposes, ranging from conscious recall to unreflected reemergence, from nostalgic longing for what is lost to polemical use of the past to reshape the present." [17] The "memorial presence of the past" to which Bal refers is vitally alive in the contemporary *lieux de mémoire* of Weems and Rothenberg.

Weems creates a living, memorial presence in her earlier installation, *From Here I Saw What Happened and I Cried* (1995–96). In this work, she pairs text and image to create a penetrating commentary on the history of racism in our country and the complicit role of photography in this history. The installation is bracketed by two indigo-dyed photographs of an African woman who witnesses the historic enslavement and continuing debasement of black people. A series of photographs are dyed red and framed in a circular black mat—the effect being that of a lens focusing on a specimen. These images are defined, dissected, and discussed through text that is sandblasted in the glass mount over the photograph. Weems takes an aggressive position throughout the installation, constantly examining the underside of American history and prodding us to see the continuation of our racism.

In one four-part section of *From Here I Saw What Happened and I Cried*, Weems illuminates history to speak to the modern representation of African Americans as sexual objects and subjects of racist humor. Here, the artist encapsulates, condenses, and interrogates the devastating effect of this stereotyping. In the upper left, the innocence and hope of childhood, embodied in a young black girl holding a bouquet of roses and overlaid by the music "God Bless the Child," is quickly dashed by the world around her. Adults act as a foil to this youthful purity. First, a woman dressed in a strapless gown and beaded headdress is labeled with an accusatory YOU BECAME AN ACCOMPLICE (figure 4). Second, African beauty becomes burlesque with the phrase YOU BECAME THE JOKER'S JOKE &. Finally, ridicule becomes derision in a graphic close-up of a black penis extending from an

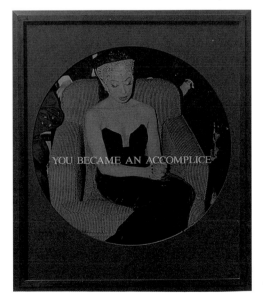

FIGURE 4
Carrie Mae Weems
You Became an Accomplice, from
*From Here I Saw What Happened
and I Cried,* 1995–96
C-print with sandblasted text on glass
26 ¾ x 22 ¾ inches

open zipper. This image, marked ANYTHING BUT WHAT YOU WERE HA, concludes the painful display of how white society has manipulated and recast the black person into a submissive and subhuman role. In the final image of this quartet, Weems appropriates Robert Mapplethorpe's own controversial representation of the black male. Mapplethorpe's *Man in Polyester Suit* (1980) displays the penis of a black man dressed in a three-piece suit. This image, which has been critically discussed in terms of its mixing of visual genres—from "pornography" to "art"—is used by Weems to expose the objectification of the black male by Mapplethorpe.[18] In this new context, it no longer seems sufficient for us to look at Mapplethorpe's photograph solely in aesthetic terms. We are forced to see it as a possible contributor to the ongoing dehumanization of black men in our country.

Our participation and complicity in history is also fundamental to Ellen Rothenberg's art. This artist takes mundane objects and then charges them with political and social meaning. During her time in Berlin shortly after the collapse of East Germany, Rothenberg was struck by the debates regarding the dismantling of memorials and the renaming of architectural sites. She responded to the national interest in reconciliation and wartime responsibility by creating a diverse selection of sculptural and performance-based props. Among them are the *Memorial to Forgetting* wreath, *We Will Die of Hygiene* broom, and *Forward/Backward* shoes (figure 5). These theatrical props emerge from Rothenberg's performance work, and they are reused by the artist in her installation projects.

Rothenberg dresses up for her performance pieces, often in outrageous costumes in which she assumes the role of the fool. She has, at various times, worn shoes made of bread, donned "an accounting suit" (a dark business suit covered with chalk marks), and pushed a broom marked VOICE. She uses the persona of the fool to create a space for conversation (figure 6). In Berlin, Rothenberg keenly sensed the more stringent codes of behavior, and she was interested in puncturing the public "bubble." For *Hello, Traitor* (1991) she humorously and pointedly inverts "the Jewish question" by proposing "the German question"—a hot-dog-shaped mouthpiece that ends in a question mark. Her absurd attire and broad humor create a public spectacle that "opens up the possibility of discussion."[19] Through her agitation by symbol, she addresses issues of public silence, complicity, and responsibility.

Spending a year in Berlin inspired both Rothenberg and Weems to create their recent installations. Rothenberg's *Beautiful Youth* emerged from her research and performance work there; Weems's *Ritual and Revolution* was created during her residency at the Künstlerhaus Bethanien. Rothenberg felt like a "detective" in this city—gathering information, going undercover, surveilling public opinion. Weems was struck by German political power and its economic boisterousness, equating that nation with our own. As foreigners, each artist was cognizant of the feeling that somehow history was closer to them in Berlin.

The manipulation of history and the production of memory reach a crescendo in Berlin. The capital of Germany may be deemed one large-scale, urban *lieu de mémoire*. The ongoing negotiation of history is palpable. For the past fifty years Germans have dealt with what critic Jane Kramer refers to as "the etiquette of commemoration." In "The Politics of Memory," Kramer pointedly

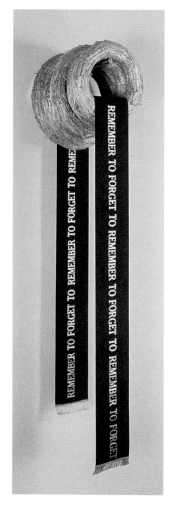

FIGURE 5
Ellen Rothenberg
Memorial to Forgetting, 1992
mixed media
60 x 21 x 24 inches

discusses the German fixation on history and its particular definition: "Germans have been trying to talk their way out of an unutterable past and back into what they like to call History. They have been talking mainly to one another. History is a German obsession and a German métier. . . . By history Germans mean German history. They call it a *Wissenschaft*, a science, but it is arguably more alchemy than science, since it has always had to do with turning the myths, memories, and language of "Germaness" into a kind of collective destiny known as the German nation."[20] History is Germany's wound and memorials are its redemption.[21] The nation's powerful interest in memorials is concentrated in its capital city. In Berlin, the questions of who and what to memorialize are hotly contested.[22] Berlin's major monuments—the Reichstag, the Brandenberg Gate, the Berlin Wall—are laden with history and lingering memories. Even seemingly mundane sites become political battlegrounds where history and memory cleave to physical locations. Every bureaucratic office, parking lot, or street intersection can contain multiple and contesting histories. Berlin, as architectural historian Brian Ladd describes it, "is a haunted city."[23]

Beautiful Youth and *Ritual and Revolution* reflect the immediacy of history. Berlin's political debates on reconciliation and the emotional turmoil over national memory inform both artists' works. Returning from Berlin, both addressed the idea of historic possibilities. In retrieving lost histories, they draw on the terms and strategies of memory. Their work is marked by heterogeneous objects and fragmentary images, malleable form of a polyphonic nature, historical inquiry, and personal force. Weems and Rothenberg announce the construction of history in the body of their art. This body is strong, resolute, and defiantly female.

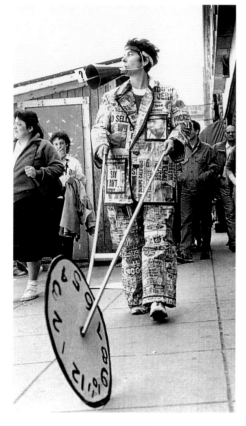

FIGURE 6
Ellen Rothenberg
The Great Circle, 1987
performance in Central Square,
Cambridge, Massachusetts

Beautiful Youth

The theme of sexual difference underlies Ellen Rothenberg's installation *Beautiful Youth*, in which we examine the definition of womanhood in modern life. Rothenberg is interested in how gender is socially manipulated and how we are complicit in that construction. The artist participates in a broader theoretical context that examines gender in ideological terms.[24] She sees femininity as both a political and a psychological representation.[25] In *Beautiful Youth*, Rothenberg creates a workroom where womanhood is produced. She uses Nazi propaganda photographs to accent the essentializing of women; she constructs worktables to underline the production of women; she presents body fragments to signify the fetishization of women; and she displays aprons to suggest the "natural" role of women. The result is a complex narrative that exposes the patriarchal definition and subsequent use of women's "essential" qualities. Rothenberg unveils how gender roles are constructed as she recovers a lost chapter from history.

At the same time, Rothenberg appropriates propagandistic images from history and reformats them for contemporary audiences. *Beautiful Youth* tells the story of Nazi youth organizations, which featured young women who served the Third Reich. Tens of thousands of young women went to camps. There they were educated, politically indoctrinated, and sent into local communities to help alleviate the labor shortage.[26] These women directly affected the war effort—their labor fed the nation, their work freed men to go to war, their care aided farmers' wives. Their roles were strictly aligned to the traditional "3Ks: *Kinder, Kirche, und Küche*" (children, church, and cooking). In Nazi Germany, this conservative construction of a specific feminine identity was deliberately and methodically promoted for the perceived good of the nation.

The state-sanctioned construction of womanhood ordered and classified gender for the Nazi regime. This was a specific campaign waged to encourage the participation of young women. The fascist construction of feminine identity is visually demonstrated and repeated throughout their propagandistic publications.[27] Physical appearance—the strong, youthful Aryan woman—was used both to index femininity and to mobilize the citizenry. The institutional use of stereotypes as a means of controlling the population has been critiqued by theorist Craig Owens: "...[T]he stereotype is truly an instrument of subjection; its function is to produce ideological subjects that can be smoothly inserted into existing institutions of government, economy, and perhaps most crucially, sexual identity."[28] In Nazi Germany beauty and charm defined the Aryan woman. This portrait was identified with biological and psychological characteristics of nurturing and empathy. These qualities were then transferred to social practices—for example, feeding children and helping neighbors. Rothenberg challenges this model of the "essential" woman by appropriating its very portrait.

FIGURE 7
Anonymous photographer, four images from Hans Retzlaff's book, *Arbeitsmaiden am Werk* (Young women at work), 1940

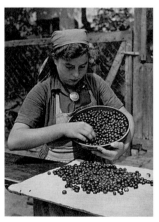
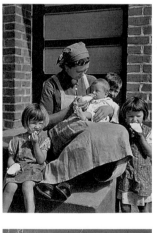
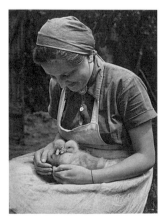
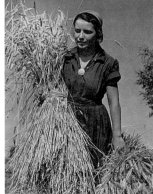

Beautiful Youth features photographs, worktables with severed body parts, and a series of linen aprons (plates 1–8). Seventeen close-up photographic images define the theme of the installation. These portraits have been selectively enlarged from propaganda books of the 1930s and early 1940s.[29] The images focus on the traditional roles given to women under Hitler's regime. With these pictures of wholesome youths at work for the national good, the books became a vehicle for the political party, an embodiment of its ideals regarding feminine "nature" and "natural" roles for women.

Rothenberg is drawn to images of women at work that focus on the ideals of nurturing, feeding, caressing, and holding that dominate Nazi publications (figure 7). Women are represented in glossy images of happy and productive young adults.

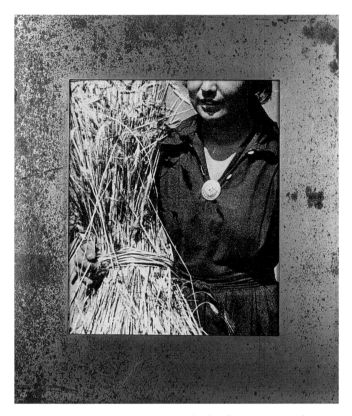

FIGURE 8
Ellen Rothenberg,
detail of installation,
Beautiful Youth, 1995–99
photograph, rusted steel frame
26 x 22 inches

We are seduced by these black and white photographs—the white skin, the smooth faces, the smiling mouths—that all fulfill the eugenic promise of fascism. In these publications we trace the recruits' typical day: raising the flag, having breakfast, setting out to work. These documentary photographs give us a sense of wholesomeness, accomplishment, and tenderness. The publications suggest that even in the midst of war, life remains stable and constant. In the midst of food shortages, the young women pictured here have plenty to eat and drink. These images impose themselves into a narrative frame—they were used as "proof" of Nazi beliefs.

Rothenberg uses the mimetic, referential power of the photograph against itself. The artist takes these images and dramatically enlarges them, removing "extraneous" information and context. Through such manipulation, she unmasks the fascist ideal of womanhood. Individuality is dismissed, and a subservience to the state is engaged. We see the smiling face of a recruit, her Nazi service brooch, and her gesture of work—feeding the baby, picking the cherries, tying the wheat, cradling the ducklings. Only the essential elements are displayed—Rothenberg conveys the woman's happiness, her servility to the Nazi program, and her tenderness (figure 8).

Rothenberg exposes the seduction of the propaganda photograph in *Beautiful Youth*. By extracting and enlarging details, the artist focuses our attention on the artificiality of the original conceit. The graininess, fragmentation, and magnification of these images expose the fascist construction of the ideal woman. Rothenberg's cropping renders that construction anonymous, and by focusing on the task depicted she emphasizes the relationship between the "happy" citizen and the state's agenda. The artist's manipulation highlights the pretense of the pose and the impossibility of this feminine ideal. The partial photographs symbolize the whole of the ideal, beautiful youth. They convey the cardinal trace of the Nazi women, one that now reads as a fetish.[30]

The artist's quotation of the wartime imagery calls attention to a particular expression of femininity and compels us to judge its merit. The German faces are enframed in rusted steel. Contrasting with the smiling Aryan youths, the frames are deliberately scratched, corroded, and pockmarked. These frames set the portraits in a distant past, yet they are still current. Rothenberg reminds us in *Beautiful Youth* that the rigid image of womanhood constructed by the National Socialists is surprisingly similar to our own. We read and negotiate these works in a particular manner—one conditioned by a lifetime of mass advertisements and media projections of the ideal woman. The smiling faces and tender poses still resonate with us today: the fascist model doubles as Madison Avenue's ideal.

The patriarchal construction of feminine identity was initially discussed by Rothenberg in her *Anne Frank Project* (1990–94). In the 1980s, a new critical edition of Frank's diary (prepared by the Netherlands State Institute for War Documentation) was published that "recovered" entries that had been edited by Anne's father, Otto Frank. While Otto Frank proclaimed that his edit retained "the essence" of Anne's manuscript, Rothenberg was critical. She examined his omissions and used textual passages in her art to discuss Anne's sexual identity. In *Das Wesentliche* (The essential) (1993), Rothenberg inscribes a set of forty-four belts with words by Anne Frank that were originally

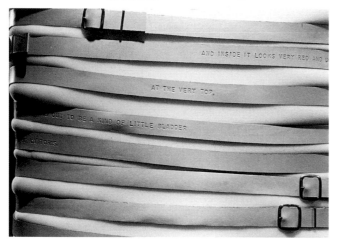

FIGURE 9
Ellen Rothenberg,
Das Wessentliche (The essential),
from *A Probability
Bordering on Certainty,* 1993
leather belts

expunged from the first edition (figure 9). In her entry of Friday morning, March 23, 1944, Anne reveals a curiosity about her genitals and supplies us with a description of her sexual organs: "… [A]nd inside it looks very red and ugly and fleshy. At the very top, between the big outer lips there is a little fold of skin which turns out to be a kind of little bladder on closer inspection, this is the clitoris."[31] The belts convey Anne's curiosity, her adolescent exploration. We read her words, spiraling around a foam-wrapped column where the belts are fastened. The reading of this material is a slow, cumulative experience, and as we walk around it, the figure of Anne Frank emerges. She is no longer a mythic figure, but human—more complicated, fully described, and emphatically feminine. This work has engendered strong responses. As the artist relates: "People can look at the belts in *Das Wesentliche* and say it's about abuse. It's about beating. It's about bondage. It's about the body. It's about corsetting. Printing a text describing skin on skin. It's about a visceral connection."[32] In her work, Rothenberg recovers the physical body of Anne Frank from the patriarch to the individual woman.

The body of the ideal Nazi maiden is similarly realized in *Beautiful Youth*. The "construction" of feminine identity is materially established in Rothenberg's workmanlike installation. Two 12-foot worktables fill the space. Constructed of wood, surfaced in steel, and illuminated by a series of suspended industrial lamps, the tables form a production area. One table is layered with the artist's fingerprints. Several leaves of translucent glassine are printed with fingerprints, which in turn are covered with beeswax drippings. The surface of the table acts as a membrane. The wrinkled face of the paper, the smudged fingerprints, and the wax marks evoke a sense of age and injury. We sense the trace of a human life laid out before us on this table.

This table is paired with another that is covered with wax body fragments. Crossed fingers, clenched fists, and stretched hands are heaped on top. Each fragment, molded from the artist's own hands, reveals the "history" of its construction in its surface. Torn edges, scratches, extrusions, and rough textures testify to the process of "making" the pieces. Their segmented nature conveys a sense of amputation. This brutality is augmented in the anatomical gestures. The hands and fingers are in tension—holding, gripping, pressing. Rothenberg creates a violent sign language

here that speaks to the manufacture, the "handling," of women. These bodies are recovered for us as was Anne Frank's sexuality.

Rothenberg deftly negotiates the issue of gender construction through the fetishistic use of body fragments. The marginality of the fetish, its existence both within and without the European value system, gives the object a rich complexity and allows it an unstable character. In his study on the fetish, William Pietz focuses on the slippery nature of this word, describing its "sinister pedigree": "It [the term *fetish*] has always been a word with a past, forever becoming 'an embarrassment' to disciplines in the human sciences that seek to contain and control its sense. Yet the anthropologist of primitive religion, sociologists of political economy, psychiatrists of sexual deviance, and philosophers of modernist aesthetics have never ceased using the term, even as they testify to its conceptual doubtfulness and referential uncertainty."[33] "Fetish" is richly ambiguous, and Rothenberg's installation embraces the term's marginal history. In *Beautiful Youth* , the fetishistic nature of the severed hands and fingers summons forth economic and psychoanalytic discourses on the enigmatic.

In *Beautiful Youth*, Rothenberg's wax multiples become part of an economic production of consumer goods displayed for us like pieces in a factory. Overhead lights accentuate and interrogate the parts. While their physical form is fixed, their value is veiled and uncertain. The enigma of these anatomical objects recalls Marx's discussion of commodity fetishism in the opening pages of *Das Kapital*. Capitalist production is typified by the creation of goods whose value is separate from its function.[34] Objects are given an exchange value that has meaning only in the modern marketplace. The objects' hidden value—their fetishistic character—is a secret, concealed reality that engages a larger social relationship. The fetishistic value "converts every product into a social hieroglyphic."[35] This enigmatic value is captured in Rothenberg's multiplication and assemblage of body parts.

Marxist ideology regarding fetishism is extended by a Freudian reading in *Beautiful Youth*.[36] The display of body parts remains unsettling. These dismembered fragments both repel and entice us. As fetishes, these body parts signify the presence of the body and simultaneously signal its loss. Freud's mechanism of fetishism is one of repression and substitution. The fetish remains, in Freud's words, "a token of triumph over the threat of castration and a safeguard against it."[37] Born of a primal horror, the fetish concretizes the traumatic event, paradoxically serving to repress it and to recreate it simultaneously. It remains as marker for the secret, ambivalent emotions brought out in certain objects. These objects serve as markers for the production of sexual identity and the consumption of the body.

The body and the sexual division of labor is called forth in the tailored aprons that hang from steel pegs on one of the walls. The linen aprons are starched and tailored. Simply designed, these work clothes are accentuated only with topstitching or the occasional ruffled edging. Rothenberg's use of stitching and fabric recalls the traditional education of a young girl as well as her future domestic role. The crisp linen surfaces recall the feminine ideal associated with a golden past and domestic stability.[38] The body of the working woman—either the domestic or industrial laborer—is evoked in these empty garments.[39]

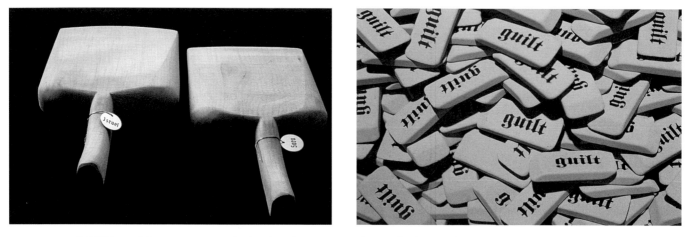

FIGURE 10 (left)
Ellen Rothenberg,
Family Portrait, from *A Probability Bordering on Certainty,* 1993
wooden vegetable scoops
with metal tags

FIGURE 11 (right)
Ellen Rothenberg,
Guilt Erasers, from *A Probability Bordering on Certainty,* 1993
printed text on rubber erasers,
unlimited edition

Rothenberg's evocation of several spheres of identity—sexual, domestic, political—is part of her ongoing investigation. In *A Probability Bordering on Certainty* (1993), the artist manufactured a number of objects that were in circulation during Anne Frank's life. These simple items are endowed with a double identity. They are both banal and highly charged with a dark history. Wooden vegetable scoops with tags marked "Israel" or "Sarah" allude to the generic names given by the Nazis to Jewish men and women; metal combs inspired by those made by prisoners at Sachsenhausen evoke images of death camp figures; and erasers printed with the word "guilt" comment on the continued denial of the Holocaust by Neo-Nazi groups (figures 10 and 11).

In *Beautiful Youth*, women are evaluated, constructed, and put into production. Rothenberg's accumulation of objects in this installation builds on and refers to the German interest in organizing and quantifying goods. In its accumulation of items—photographs and fingers, aprons and pegs—*Beautiful Youth* conveys a mounting sense of meaning as we proceed through the installation. Understanding and knowledge come through an engagement with the body of information offered us.

In both her installation art and her performance work, Rothenberg touches on history in a firm, yet supple manner. Her projects are framed by a series of questions and resist any monolithic description of history. She recovers narratives and raises issues that have been lost or deliberately overlooked. And, most ambitiously, she unveils ideological constructions of history that have gone unchallenged.

Ritual and Revolution

An unveiling of history is similarly engaged in Carrie Mae Weems's *Ritual and Revolution*. This project, comprising multiple banners of sheer muslin, invites us into a broad historical overture—a symphonic presentation of First- and Third-World cultures through time. History is layered here, both conceptually and materially, in the digitally printed images. Weems's story is inclusive, one that embraces classical temples and African slave sites, European palaces and Mayan ruins. As we walk around the banners, we sense the vastness of civilization, the triumph of dominant cultures, and the ongoing struggle of vanquished people. Yet Weems offers hope in the face of overwhelming strife through her "participation" and very presence in this installation.

Ritual and Revolution takes the form of a journey. The series of banners is suspended to form a narrative pathway (plates 9–16). As in previous installations by Weems, the narrative is flexible within a given structure. While the first and final images are set, the middle section shifts from one installation site to another. Like all good tales, this narrative begins simply and boldly. *Ritual and Revolution* starts in Asia Minor, the "cradle of Western civilization," and Weems, a contemporary African American woman, is at its center.

At the entry point to *Ritual and Revolution*, Carrie Mae Weems poses as a Hellenic goddess. Weems, her body swathed in a column of fabric, is the embodiment of classical sculpture. Perfectly poised, her head tilts, her body sways slightly, her hands lightly touch each other. She both inaugurates and guides our journey. The artist/goddess is attended by a pair of Greek *korai* statues that are situated behind her. Each of these female youths holds a small animal in her hand as a sacrificial offering. These dedicatory sculptures were primarily displayed in ancient sanctuaries.[40] The figures have a sense of reserve. Formally occupying a vertical plane, their bodies are composed of cylinders that are delicately carved with linear detail. These statues impart grace and monumentality, refinement and majesty.

The glory of the dark-skinned goddess and her attendants is completed by the classical colonnade that enframes them. The artist positions herself on the grand stairway of the Great Altar at Pergamon, one of the central monuments of the Hellenistic age. This temple is known for its theatricality. Like Weems's costume, its marble columns are deeply cut and fluted. The colonnade brackets the artist's self-portrait, providing an architectural weight and drama to the installation's entry.

Weems's guise as a kind of "Black Athena" is a subversive gesture.[41] The artist assumes a persona that immediately decenters the traditional narrative that Western civilization arose in classical antiquity and led in a linear manner through the millennia to European domination. Her image as goddess undercuts the standard gloss of history and interrogates biases.

Weems has used the strategy of masquerade effectively in previous work. In her *Kitchen Table* project (1990), Weems positions herself at the head of a table where she becomes an actress in an ongoing drama (figure 12). A series of tableaus are played out before us. Weems gossips with friends, eats a meal with a lover, finishes homework with her child. Under a strong overhead light, the

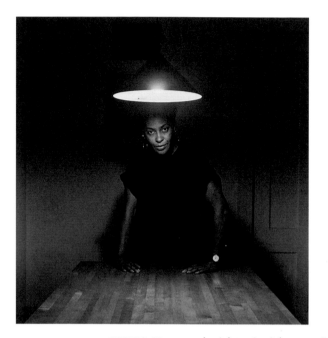

FIGURE 12
Carrie Mae Weems,
Untitled (Woman Standing Alone),
from *Kitchen Table Series,* 1990
silver print
27^1/$_4$ x 27^1/$_4$ inches

domestic life of this woman is interrogated by the artist. The visual documentation is accompanied by intimate text panels that reveal the woman's private doubts, beliefs, and ambitions. The confessional nature of this series moves the protagonist beyond our consuming gaze. In these tableaus, the woman is in control. Weems as author and subject seizes the spectator's gaze and turns it back at us. She asserts herself and articulates relationships that complicate and refute racial and gender stereotypes.[42] Weems creates a site of resistance through this persona, as she does in the visage of the goddess.[43]

This same critical gesture seen in *Ritual and Revolution* is furthered by Weems's use of the image of the Pergamon temple. The structure is an icon of the "foundations" of Western culture, and its appearance reminds us of a more complex history of colonial exploitation. The colonnade signifies both the classical past and also the European appropriation of that heritage. Western nations used ancient artifacts to legitimize and bolster their claims to national greatness and colonial territorial expansion. The Great Altar of Pergamon is one of the most significant of all German colonial trophies. It was brought to Berlin in 1890 from Turkey and was quickly recognized for its powerful, astonishing imagery.[44] It immediately defined German ambitions to become a cultural center. German interest in classical antiquity was particularly strong in the late nineteenth century as the nation was remaking itself as a power. There was—and is—a powerful link between the monumental and the artifacts of classical antiquity. Even in their fragmentary form, Hellenic artifacts provided an important grounding for European nations. As Andreas Huyssen comments in "Monumental Seduction": "While classical monuments provided European nations an anchoring in their cultural roots (think of the tyranny of Greece over Germany), the search for national monuments first created the deep national past that differentiated a given culture both from its European and its non-European others. As ever more monuments were unearthed…the monument came to guarantee origin and stability as well as depth of time and space in a rapidly changing world that was experienced as transitory, uprooting, and unstable."[45] In *Ritual and Revolution*, the German veneration and appropriation of the classical past is reappropriated by Weems to expose the European consumption of other cultures. Within the temple sanctuary, Weems subverts the traditional reading of the linear evolution of Western civilization.

From Homeric antiquity, the visual pilgrimage skips across geographic boundaries and through time. The artist takes us on a voyage through the continent—giving us a grand tour of European power and domination. Western constructions of nature and nation form the next set of images: a row of trees in Berlin, a statue in Paris's Jardin des Plantes, a view of Versailles. This last image is an icon of national power. Versailles was Louis XIV's monument of self-glorification, a lasting testament to the glory of his reign. The Sun King epitomized the omnipotence of royalty during

the Baroque age, and Versailles reflects this sense of majesty. Its double staircase sweeps upwards to a central doorway; architect Louis Le Vau's grand entrance design dramatically declares regal power.

Weems's telling of history, however, is emphatically non-Eurocentric. The conquered civilizations of the past are the subject of the next set of images. A Portuguese trading depot in Ghana that was used to warehouse captives for the slave trade is depicted in a benign detail: a cobblestone walkway leading to an arched doorway. The painful history of exploitation and enslavement lies behind high white walls and beneath ruins. A view of Tulúm, a late Mayan city that was occupied at the time of the Spanish conquest of Mexico, follows. Weems's image shows its characteristic Yucatán architecture: simple boxlike structures banked by steeply angled stairs. We next travel northward to the Hopi sites of the western United States. Weems appropriates and crops Edward S. Curtis's image of young Native-American women. The photograph, *Watching the Dancers,* shows a group of Hopi girls with their backs toward us, on the top of a roof in the community of Walpi.[46] Weems's use of Curtis's work allows her to recast his documentary image into her own critical context.

For Weems, the process of appropriation here is not one of simple quotation to avoid authorship, but a strategy that allows an extension and revision of the original narrative. For Curtis, photographing Native Americans was a mission to salvage for posterity the history and the cultures of the "savage." A passage of text that originally accompanied this 1906 image reveals Curtis's romantic view of Hopi culture: "A group of girls on the topmost roof of Walpi, looking down into the plaza. Picturesque Walpi, perched on the point of a rocky island in a sea of sand, is an irregular, rambling community; built without design, added to in haphazard fashion as need arose, yet constituting a perfectly satisfying artistic whole." [47] Curtis's "picturesque" village becomes politicized in *Ritual and Revolution.* In Weems's project, the young girls join other cultures that have been destroyed by white colonialization. They are taken out of the realm of nostalgic longing and become contemporary icons of loss. Weems's image creates an ideological space between the "authentic" Curtis image and her "appropriated" print that allows for a rich, complex discussion of meaning.

Narratives of loss and mourning are present in these images of conquest. Weems evokes these stories as a deliberate act to recover and reconstitute a past. Her use and appropriation of the documentary challenges the traditional objectivity associated with straight photography. In an interview with bell hooks, Weems discusses her initial interest in photography and how that terrain could no longer handle her art:

> Documentary as a genre has been very, very interesting to me.... Early on, my artistic practices were shaped by those traditions that said: This is how a photograph is made. These are the elements of a good photograph. This is the way the shit's supposed to be printed. Then you know that you were working in that mode. And I tried that. I worked with it and there was something appealing about it, the whole idea that you were somehow describing the complicatedness of the human condition. That's what documentary was, or certainly was to me.

I think a part of documentary had a lot to do with the notion that you would go into somebody's backyard and capture it and bring home the ethnic image, a trophy.... However, when I started to understand it, when I learned that the terrain that I wanted to walk on couldn't be carried forth by straight documentary, my attention shifted. There was something different that I wanted to explore, work that had the appearance of documentary but was not at all documentary. It was highly fabricated work.[48]

In *Ritual and Revolution*, she makes us aware of the construction of meaning through images. The unveiling of "truth" is furthered in the next set of images.

After an elegiac dialogue with the past, Weems brings us visions of recent terror. Our sense of complacency is shattered in the figures of Holocaust victims, the close-up of bound and blindfolded Cambodian prisoners, and the snapshot of civil rights demonstrators in the streets of Montgomery, Alabama. All of these images are appropriated from sources that Weems has collected over the years—a book on the Holocaust, a memoir of *The Killing Fields,* a Charles Moore photograph. There is a personal attachment between Weems and these images; she has carried many with her for several years. These historical images merge with her own story, her own history.

The appropriated photographs provide historical touchstones, familiar images that tug at our memory of war, trauma, and racism. Weems magnifies portions of the original images to focus on profound suffering. The images are recast and find new meaning: the Holocaust document now joins other images, placing the suffering of Jews in the larger context of worldwide oppression; the ropes and blindfolds over the Cambodian prisoners now denote our common bondage; the recording of Alabama civil rights demonstrators now reads as a testament to perseverance. These final images are reminders of ongoing strife. This terror is mitigated by the sheerness of the fabric. As writer Ernst Larson cogently remarks: "[In] *Ritual and Revolution*, such images are as permeable to light, to the fragility of light, as they should be to emotion, intellect, understanding. Such animation, permeability, and vulnerability, when taken together work to produce the conviction that this ruinous history is far from being over and done with—that there are visceral connections between past and present being made here."[49] Weems purposely closes the installation with a confluence of races—European, Asian, African American—emphasizing our common struggle. The journey ends with these acts of resistance.

The historic struggle of the oppressed is brought to the forefront by the overlay of Weems's voice in the installation. Her deep, melodious voice recalls historic points of rupture and heralds repeated calls to justice. She acts as a witness to the painful history:

> *From the ruins of what was and what will be*
> *I saw your longing*
> *felt your pain*
> *and tried to comfort you*

Weems gives a personal face to history and makes us aware of the underlying narrative of loss. Her mournful phrases mark these images of conquest.

Weems becomes the voice of the survivor. In verse, she reopens the wounds from history with the refrain, *"I was with you"*:

> *…in the ancient ruins of time*
> *…when you stormed the Bastille &*
> *…in the hideous mise en scene*
> *of the Middle Passage*
> *…in the death camps*
> *…on the longest march*
> *…in Santiago*
> *attempting to block*
> *an assassin's bullet*
> *and again in Harlem*
> *cradling Malcolm to my bosom crying*

The repetitive phrase, *"I was with you,"* weds the artist to history. Like a Baptist hymn, the verse serves as a testimonial to Weems's faith. She is an eyewitness to the great spectacle of history and the monumental tale she describes endows her art with an ongoing sense of moral commitment. Larsen identifies Weems's negotiation of the past: "The traversal of this refrain stakes out the long troubled circumstances of art's attempted communion with revolutionaries, slaves, victims, and workers, those who in a collective sense produced the residue we call history."[50] The next set of verses contains the refrain, *"I saw…,"* which confirms her vision:

> *I saw everlasting death…*
> *I saw you and your father…*
> *I saw your fear of pleasure…*
> *I saw men and women…*
> *I saw your hands replaced…*
> *I saw nor heard any mention of…*
> *I saw you moving through…*
> *I saw you bewildered, startled & stumbling…*
> *I saw your longing…*

She witnesses fear and death, struggle and malaise. The gaze of the artist becomes our historical lens. As Weems continues her descent from historical tragedy to social corruption to personal grief, we hear her voice saying *"I spied…I swooped."* The artist infiltrates and interrogates history. In the passage of time Weems moves from witness to accomplice (*"I too felt the allure of temptation's temptress"*), and is then reborn from this corrupt state to find redemption. She concludes with a list of those who have personally sustained her—people who have acquiesced or persevered in

FIGURE 13
Carrie Mae Weems,
installation view,
Who What When Where, 1998
mixed media

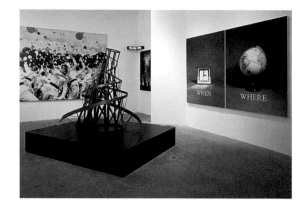

the struggle: Stanley (Crouch), Lorna (Simpson), bell (hooks), Felix (Gonzalez-Torres), and Anna (Devere Smith). In the final stanza, she emerges into the present, into hope: "*& I could see again.*"

Weems's vocal overview of history spirals downward through time to the present. Her verse moves from ancient ruins to the storming of the Bastille to Malcolm X's assassination. This history is organic, nonlinear. In the imperative nature of her voice and the persistent motif of sight, Weems is artist, seer, and prophet. The uniqueness of her voice—the equivalent of Rothenberg's fingerprints—imparts a signature to this pilgrimage. Indeed, Weems's voice gives an emotional weight to the translucent membranes of the banners. As we move through the installation, her intonations and melancholic recitations fill the space. Weems's voice resonates and transports us from grand history into a collective memory. She elegizes the long history of domination and oppression in what has been characterized by W. E. B. Du Bois as "sorrow songs." Her telling history counters the suppression of voice.[51] At the end is redemption.

The polyphonic *Ritual and Revolution* engages Weems's long-standing use of text. The artist's fascination with folklore began in the late 1970s when she was working on her *Family Pictures and Stories* (1978–84). In this series the artist broke away from the studied photograph and used "snapshot" images accompanied by intimate texts told in the first person.[52] The casual, yet potent quality of this oral tradition defines her family in a vital manner. The addition of text breaks the supposed objectivity of documentary and allows Weems to expand and direct the discourse of the photograph.[53] This doubling of image and text, a gesture she shares with many artists of color,

FIGURE 14
Carrie Mae Weems,
Who, What, When, Where from
Who What When Where, 1998
digital photographs on canvas,
color pigment
each 84 x 66 inches

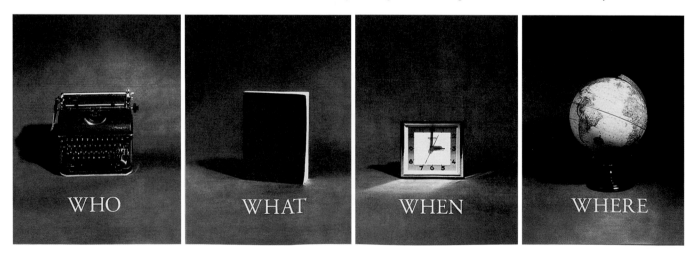

allows Weems to speak on several simultaneous levels in her work.[54] It becomes a tool in her arsenal for resistance and remembrance.

Weems's *Who What When Where* (1998) is the fraternal twin to *Ritual and Revolution*—an installation that raises questions about our participation in history and our complicity in the status quo (figures 13 and 14). Her interrogation includes the role of art in society. In one triptych, Weems pairs aesthetic utopianism with political complicity (figure 15). The artist conflates Malevich's *Black Square* and *Red Square* with a gramophone horn. Under the antique horn runs the text:

I REMEMBER LONG NITES AND ENDLESS DISCUSSIONS WITH YOU,
WHEN WE WERE NOT AFRAID TO SPEAK OUR MINDS, AND NOW I
ONLY FEEL THE HUSH, HUSH, HUSH OF OUR MUTUAL SILENCE.

FIGURE 15
Carrie Mae Weems,
Red Square or Position of Native Peoples; The Hush of Your Silence; Black Square or Dancing in Congo Square,
from *Who What When Where,* 1998
digital photographs on canvas,
color pigment,
left and right each 56 x 72 ¹/₂ inches;
central image 84 x 66 inches

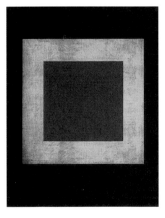

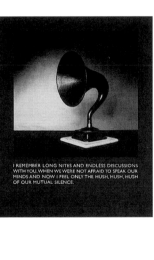

There is an unsettling and profound disjuncture—a fissure—between the "silence" of the text and the horn that fails to amplify the sound. Malevich's geometric compositions—two icons of twentieth-century abstraction—bracket this unsettling silence and become part of the duplicity. The once-revolutionary modernism, which originally defined art's purity from objective reality, is now exposed.[55] Weems opens up a space in this work to question the relationship between the avant-garde and the status quo.

A critical reading of history and its "accomplices" is similarly apparent in *Ritual and Revolution* as Weems provides both her body and voice for this journey. In her latest work, she positions herself as the bearer of history—an unofficial, unacknowledged history that has been kept alive through the body and gestures, songs and sorrows of the oppressed.

Telling Histories

Both Weems and Rothenberg have been informed by feminist art, theory, and politics. In each of their recent installations, "woman" is the protagonist. For Weems, woman is personified as a beatific goddess emerging from ancient times; for Rothenberg, she is a modern youth born out of the union between social agenda and patriarchal gaze. Politics and memory, sexuality and history are imprinted on the body of this art. Values are physically inscribed as each artist questions our collective memory and interrogates history.

The artists' histories are neither simple nor singular. Instead, Rothenberg and Weems complicate their stories. In *Beautiful Youth*, Rothenberg appropriates both stereotypic image and male gaze to interrogate the construction of feminine identity. Her installation demonstrates the commodification of women in the 1940s as it questions our own contemporary identities. Weems similarly investigates history's current meaning. By embodying the history itself—in the physical form and vocal "apparition"—she challenges the master narrative and embraces the histories of the disenfranchised.

Ritual and Revolution and *Beautiful Youth* lead us to new ways of thinking about history. They suggest that gender must be constantly redefined and restructured and that our participation must be continually questioned. There is in each artist's work and life a sense of commitment that opposes much of the silence that engulfs our society. Weems and Rothenberg came of age in the 1960s and 1970s, and the social upheaval of this period made a mark on both. Their art practice continues the call for political action. Each seizes the reins of the narrative away from the patriarch to construct new critical narratives that reclaim "woman" and her story.

Notes

1. Judith Wilson, "New (Art) Histories: Global Shifts, Uneasy Exchanges," in *New Histories*, ed. Lia Gangitano and Steven Nelson (Boston: The Institute of Contemporary Art, 1996), 16.

2. Cox and Stromquist mention several major sources for this sense of disarray, including the rise of social history that features nonelitist, "low" subject matter. In both Britain and the United States, some of the most vital work has been in feminist history:

 "Gendered" histories decentered traditional narratives in a variety of ways and subverted the project of constructing a new master narrative. They opened new intellectual space for alternative accounts of the social relations of power, languages, and structures of domination, and subjectivity gained credibility and persuasive power.

 See Jeffrey Cox and Shelton Stromquist, *Contesting the Master Narrative: Essays in Social History* (Iowa City: University of Iowa Press, 1998), 2.

3. Lawrence Levine and Joan Wallach Scott, quoted in Cox and Stromquist, 3.

4. Issues of gender identification in Weems's work have been overlooked in favor of racial commentary alone. The artist has expressed outrage over the one-dimensional nature of criticism of her work. Conversation with the author, December 1998. See also bell hooks, "Talking Art with Carrie Mae Weems" in *Art on My Mind, Visual Politics* (New York: The New Press, 1995), 74–93.

5. The *Sea Islands Series* deals with the contemporary resonance of slave history for African Americans. In her words, Ms. Weems presents herself in this work as "a person pained by the overall slave experience," Conversation with the author, 8 July 1999.

6. Carrie Mae Weems, *In These Islands: South Carolina, Georgia* (Tuscaloosa, Alabama: University of Alabama, Sarah Moody Gallery of Art, 1995).

 For the *Sea Islands Series,* Weems culled these sayings from Zora Neale Hurston's collections of essays: *Mules and Men* (1934), *Negro: An Anthology,* and *The Florida Negro* (1938). Other sources include Lydia Parrish, *Slave Songs of the Georgia Sea Islands* (1942); Elsie Clews Parsons, *Folk-lore of the Sea Islands, South Carolina* (1923); and Newball Niles Puckett, *Folk Beliefs of the Southern Negro* (1926). I would like to thank Kathryn Delmez for researching the folk sources in the *Sea Islands Series*.

7. Peter Ackroyd, "Biography: The Short Form," in the *New York Times,* 10 January 1999, 4.

8. It has, like all diaries, a highly valued immediacy; the act of her writing coincides with the actual events described in her journal. For a discussion of the issue of directness in the genres of testimony and auto-biography for Holocaust studies, see Ernst van Alphen, *Caught by History: Holocaust Effects in Contemporary Art, Literature, and Theory* (Stanford, Calif.: Stanford University Press, 1997), part I, 41–92.

 For an overview of the critical debate around the various versions of the diary, see Cynthia Ozick, "Who Owns Anne Frank?" *The New Yorker* (6 October 1997): 76–87.

9. Whitney Chadwick, "Ellen Rothenberg: A Probability Bordering on Certainty" in *Ellen Rothenberg* (Cambridge, Mass.: The Mary Ingraham Bunting Institute of Radcliffe College, 1993), n.p.

10. Ellen Rothenberg quoted in Johanna Branson, "Interview with Ellen Rothenberg," in *Ellen Rothenberg,* ed. Johanna Branson (Medford, Mass.: Tufts University Art Gallery, 1994), 13.

11. Natalie Zemon Davis and Randolph Starn, "Introduction" to *Memory and Counter-Memory, Representations* 26 (Spring 1989): 2.

12. Pierre Nora, "Between Memory and History: *Les Lieux de Mémoire*" in Davis and Starn, 9.

13. Ibid., 7.

14. Ibid.

15. Ibid., 12.

16. The nature of memory and the construction of contemporary memorials have come to the foreground of public debate surrounding the Holocaust and how to appropriately remember this event. Nineteen ninety-five marked the fiftieth anniversary of the end of World War II. This anniversary served to make people aware of the aging generation of Holocaust survivors and to ponder the importance of their testimony.

 Among the many scholars in the field of Holocaust studies, Geoffrey H. Hartman, Andreas Huyssen, Lawrence L. Langer, and James E. Young produce particularly strong work. For a single anthology of their ideas, see "Papers from the Tenth Anniversary Conference of the Fortunoff Video Archive for Holocaust Testimonies at Yale University on 'The Future of Memory,'" in *The Yale Journal of Criticism* 6/2 (Fall 1993): 239–84.

17. Mieke Bal, "Introduction" in *Acts of Memory: Cultural Recall in the Present,* eds. Mieke Bal, Jonathan Crewe, and Leo Spitzer (Hanover, NH: University Press of New England, 1999), vii.

18. In the 1990s, Robert Mapplethorpe's erotic images focused national debate on the issue of censorship. His work was, and continues to be, viewed as pushing the boundaries of erotic representation. He achieved notoriety with his photographs of black male models and with his graphic imagery. The image that Weems appropriates has been used to illustrate the photographer's interest in pulling the viewer between the two categories of "art" and "pornography" and confusing the genres. See Janet Kardon, *Robert Mapplethorpe: The Perfect Moment* (Philadelphia: Institute of Contemporary Art, University of Pennsylvania, 1989).

For a critical discussion of the representation of African American men in recent art, including an excellent bibliography, see Thelma Golden, ed., *Black Male: Representations of Masculinity in Contemporary American Art* (New York: Whitney Museum of American Art, 1994).

19. Conversation with the author, 25 January 1999.

Rothenberg's ongoing interest in "agitation by symbol" is seen in her upcoming project on the Suffrage movement.

20. Jane Kramer, "The Politics of Memory" in *The New Yorker* (14 August 1995): 48.

21. Andreas Huyssen has written cogently of current German memorializing in "Monumental Seduction" in Bal, 192.

> In today's Germany, redemption through memory is the goal. It was particularly striking during the events marking the fiftieth anniversary of the end of the Nazi war of extermination that the discourse of redemption (*Erlösung*) had all but replaced the earlier discourses of restitution (*Wiedergutmachung*) and reconciliation (*Versöhnung*). Indeed, the Germans have eagerly appropriated the first part of the old Jewish saying "the secret of redemption is memory" as a strategy for Holocaust management.

22. The difficulty in reaching an agreement over the role and vocabulary of memorials is seen in the very public—and often bitter—discussion concerning a Holocaust memorial in Berlin. A design by New York architect Peter Eisenman was recently approved after a decade-long debate. See Roger Cohen, "Berlin Holocaust Memorial Approved," *New York Times*, 26 June 1999.

23. Brian Ladd, *The Ghosts of Berlin: Confronting German History in the Urban Environment* (Chicago: University of Chicago Press, 1997), 1.

24. For a discussion on sexual difference and the relationship of that concept with patriarchal notions of essentialism, biologism, naturalism, and universalism, see Elizabeth Grosz, "Sexual Difference and the Problem of Essentialism" in *Space, Time, and Perversion* (New York: Routledge, 1995), 45–57.

25. Lisa Tickner clearly lays out recent theoretical shifts in writings regarding gender construction that involve the confluence of Marxism, poststructuralism, feminism, and psychoanalysis. She writes:

> The critical European component in the debate has been the theorization of the gendered subject in ideology— a development made possible, first, by Althusser's reworking of base/super-structure definitions of ideology in favor of the ideological as a complex of practices and representations, and second, by the decisive influence of psychoanalysis (chiefly Lacan's rereading of Freud).
>
> It was psychoanalysis that permitted an understanding of psycho-social construction of sexual difference in the conscious/unconscious subject. The result was a shift in emphasis from equal rights struggles in the sexual division of labor and a cultural feminism founded on the revaluation of an existing biological or social femininity to a recognition of the processes of sexual differentiation, the instability of gender positions, and the hopelessness of excavating a free or original femininity beneath the layers of patriarchal oppression.

See Lisa Tickner, "Sexuality and/in Representation: Five British Artists," in *The Art of Art History: A Critical Anthology,* ed. Donald Preziosi (Oxford: Oxford University Press, 1998), 356.

26. At the time of publication in 1940, one document proclaimed that there were more than eight hundred camps and an expected 52,000 participants in the young women's youth corps. These youth corps for women began in 1933. See Hans Retzlaff, *Arbeitsmaiden am Werk* (Leipzig: Verlag E. A. Seeman, 1940), 14.

27. The use of photography, a medium which is uniquely documentary and reproducible, was and remains a highly useful tool for governmental campaigns. During the 1930s, photography was used extensively not only in Germany, but also in the United States as seen in the massive FSA production during the Depression. For a general critique of the political and institutional acts of photography, see Richard Bolton, ed., *The Contest of Meaning: Critical Histories of Photography* (Cambridge: MIT Press, 1989). For an introduction to the use of documentary photography, see Maren Stange, *Symbols of Ideal Life: Social Documentary Photography in America, 1890–1950* (New York: Cambridge University Press, 1989) and John Tagg, *The Burden of Representation: Essays on Photographies and Histories* (Amherst: University of Massachusetts Press, 1988).

28. Craig Owens, quoted in Rosemary Betterton, *An Intimate Distance: Women, Artists and the Body* (New York: Routledge, 1996), 167.

29. One of several books that Rothenberg examined in the Schlesinger Library at Radcliffe College was Retzslaff's 1940 *Arbeitsmaiden am Werk* (Young women at work). This text exemplifies the Nazi ideal of womanhood. The propaganda volume promotes the rapidly growing youth camps for girls, noting their importance for the young woman, their benefit to the citizenry, and their aid to the labor shortage. This "volunteer" service is designated as a gift by the Führer to help girls know and

love their country. Lessons in loyalty and Nazi policy were included with the work service. The camp became a cultural focal point. Daily rituals of raising and lowering the flag, along with nationalistic songs and political instruction rallies marked the young recruits' day. Individualism was actively discouraged. These young women were all identified by their standard dress and the silver brooch that they wore at the collar—a circular pin with the swastika framed by two shafts of wheat and emblazoned with the phrase *"Reichsarbeitsdienst Weibliche Jugend"* (Female youth work service for the Reich). See Retzlaff, op cit.

Ellen Rothenberg appropriated photographs from the following publications: Ibid.; Gustav V. Estorff, *Das die Arbeit Freude werde!* (Berlin: Verlag Wilhelm Undermann, 1938); Dr. Frieda Sopp, *Der Reichsarbeitsdienst der Weiblichen Jugend* (Berlin: H. Bürtner, n.d.); and Gertrud Schwerdtsege-Zypries, *Das ist der Weibliche Arbeitsdienst* (Berlin: Junge Generation Verlag, 1940).

30. Rothenberg's use of photographic material engages the concept that a photograph is both a memory and also a countermemory and is related to Barthes's discussion of the *punctum.* He reads in a photograph a sense of *"This will be* and *this has been."* See Roland Barthes, *Camera Lucida: Reflections on Photography,* trans. Richard Howard (New York: Hill, 1981), 96.

31. Anne Frank, *The Diary of Anne Frank: The Critical Edition, Prepared by the Netherlands State Institute for War Documentation* (New York: Doubleday, 1986), 567.

32. Branson, 16.

33. William Pietz, "The Problem of the Fetish, I," *Res* 9 (Spring 1985): 5.

34. Karl Marx, *Capital, A Critique of Political Economy,* ed. Frederick Engels, trans. Samuel Moore and Edward Aveling (New York: The Modern Library, 1906), 82.

35. Ibid., 83.

36. In her investigation of the fetish in nineteenth-century literature, Emily Apter notes that Marx's conception of the fetish as a "socioeconomic hieroglyph" is "curiously compatible" with Freud's sense of the strangeness of the fetish. Both Marx and Freud use the term *fetish* in their respective theories to describe the enigmatic. See Emily Apter, *Feminizing the Fetish: Psychoanalysis and Narrative Obsession in Turn-of-the-Century France* (Ithaca: Cornell University Press, 1991), 1–2.

37. Sigmund Freud, "Fetishism" in *Collected Papers,* vol. 5, ed. James Strachey (New York: Basic Books, Inc., 1959), 198.

38. Embroidery was historically part of a young woman's education and a means of evaluating her class. Harris notes that in the modern period embroidery was associated with an idealized view of the past and became associated with domestic stability: "Embroidery came to be seen not primarily as a badge of leisure but as a

contribution to the happiness and well-being of the home." Jennifer Harris, *The Subversive Stitch: Embroidery in Women's Lives, 1300–1900* (London: Whitworth Art Gallery, 1988), 18.

Rothenberg is critically aware of this history. In her project, *For the Instruction of Young Ladies* (1989), the artist creates a series of samplers to comment on the traditional advertising of a girl's skills.

Clothing, along with its associated materials and methods of construction, has been used by several contemporary women artists to represent the body and to critique feminine identity. See Nina Felshin, "Women's Work: A Lineage, 1966–94," *Art Journal* 54/1 (Spring 1995): 71–84.

39. Women and their labor is a theme that has occupied Rothenberg for much of her career. At the time she discovered the Nazi propaganda material that would inspire *Beautiful Youth,* the artist was researching the mottoes and speeches of the Lowell Female Labor Unions for her public art piece entitled *Industry, Not Servitude.* This project, created for the Department of the Interior, commemorates the role of women in the American labor movement. Here, Rothenberg decided to let the women speak for themselves in a series of poems, mottoes, quotations, and documents. This heterogeneous mix of source material allowed the voices of largely unknown and uncommemorated women to be heard.

40. Korai were also used as markers for women's graves. They were distinguished from their male counterparts (kouroi) by the fact that they are always shown clothed. See Robin Osborne, *Archaic and Classical Greek Art* (New York: Oxford University Press, 1998), 75–85.

41. Weems as the "Black Athena" is theorized by Ernst Larsen in his essay, "Between Two Worlds," in Carrie Mae Weems, *Ritual and Revolution* (Berlin: Künstlerhaus Bethanien, 1988), 5.

42. The artist is critical of feminist theory as generally overlooking women of color. For her critique of Laura Mulvey's writings on "the gaze," see Carrie Mae Weems, speech given at the School of the Art Institute of Chicago, Visiting Artists Program, 20 April 1992. I would like to thank Sydelle Rubin for bringing this citation to my attention and for engaging my interest in the issue of Weems's feminism.

43. It is interesting to consider Carrie Mae Weems's projection of herself in this installation in terms of a larger African American practice. In his essay on "Black Culture and Postmodernism," Cornel West looks at the discursive space of "postmodernism" and African American cultural practices and products. "A distinctive feature of these black styles is a certain projection of the self—more a *persona*—in performance. This is not simply a self-investment and self-involvement… it also acknowledges radical contingency and even solicits challenge

and danger." See Cornel West, "Black Culture and Postmodernism," in *Remaking History,* ed. Barbara Kruger and Phil Mariani (New York: Dia Art Foundation, 1989), 93.

44. Upon the temple's arrival in Germany, a separate museum was built to house this archaeological treasure. The result, ironically, is a Hellenic sanctuary wrapped within the folds of a European museum—our own cultural temple. This temple, which was the visual manifestation of Pergamon's desire to be seen as the new Athens, was in turn used by Germany to proclaim its own cultural greatness. See Esther V. Hansen, *The Attalids of Pergamon* (Ithaca: Cornell University Press, 1971), xix. For a general overview of Greek art, see John Boardman, ed., *The Oxford History of Classical Art* (Oxford: Oxford University Press, 1993).

45. Andreas Huyssen, "Monumental Seduction" in Bal, Crewe, and Spitzer, 200.

46. Edward Curtis photographed Native American peoples for approximately thirty years. His lifework culminated in a monumental twenty-volume series entitled *The North American Indian* (1907–1930). Curtis, like many of his contemporaries, believed that Native Americans were doomed to vanish. His photographic efforts joined scholarly pursuits by Lewis Cass, Henry Rowe Schoolcraft, Lewis Henry Morgan, George Bird Grinnell, and John Wesley Powell. For more information on this photographer, see Edward S. Curtis, *In a Sacred Manner We Live: Photographs of the North American Indian by Edward S. Curtis* (Barre, Mass.: Barre Publishers, 1972); Edward S. Curtis, *The North American Indians: A Selection of Photographs by Edward S. Curtis* (New York: Aperture, 1972); and Edward S. Curtis, *Portraits from North American Indian Life* (New York: American Museum of National History and E. P. Dutton & Co., 1972).

47. Chistopher Cardozo, ed., *Native Nations: First Americans as Seen by Edward S. Curtis* (Boston: Little, Brown and Company, 1993), 129.

48. Carrie Mae Weems, "Talking Art with Carrie Mae Weems," in bell hooks, *Art on My Mind: Visual Politics,* 81–82.

49. Larsen, "Between Two Worlds," 4.

50. Ibid, 5.

51. These "sorrow songs" of African American writers create a new genre of poetic lament—remaking the European genre while they are critiquing these literary forms. For a discussion on the African American elegy and the blues, see Jahan Ramazani, *Poetry of Mourning: The Modern Elegy from Hardy to Heaney* (Chicago: The University of Chicago Press, 1994), 135–42.

52. Upon completing this series in 1984, Weems began a Master's program in folklore at the University of California at Berkeley. For a discussion of this series and her interest in folklore, see Andrea Kirsh and Susan Fisher Sterling, *Carrie Mae Weems* (Washington, DC: The National Museum of Women in the Arts, 1993).

53. Many women artists of color incorporate text in their art as a way of clarifying the reception of their work. As in Weems's work, the joining of text and image helps ground meaning in the image, leaving less chance for misrepresentation. For an overview of this strategy in contemporary art, see Kellie Jones, "In Their Own Image," *Artforum* (November 1990): 133–39.

54. The assemblage of multiple voices in African American literature and its use as an act of critical intervention and resistance is discussed by Henry Louis Gates in *The Signifying Monkey* (New York: Oxford University Press, 1988).

55. The "conspiracy" between the avant-garde and the status quo is central to Weems's art and politics. Weems continues the critique of modernism in *Who What When Where* through sculpture. In this installation, Weems references the social engagement of the Russian constructivist by replicating Vladimir Tatlin's *Monument to the Third International* (1920). Like Malevich's spare geometry, this spiralling form is an icon to the utopianism of the interwar years. Weems goes back to a time in history when artists were actively addressing social issues and involving themselves in the politics and production lines of society. Deeply attracted to constructivism, Weems is similarly interested in the demise of the privileged art object.

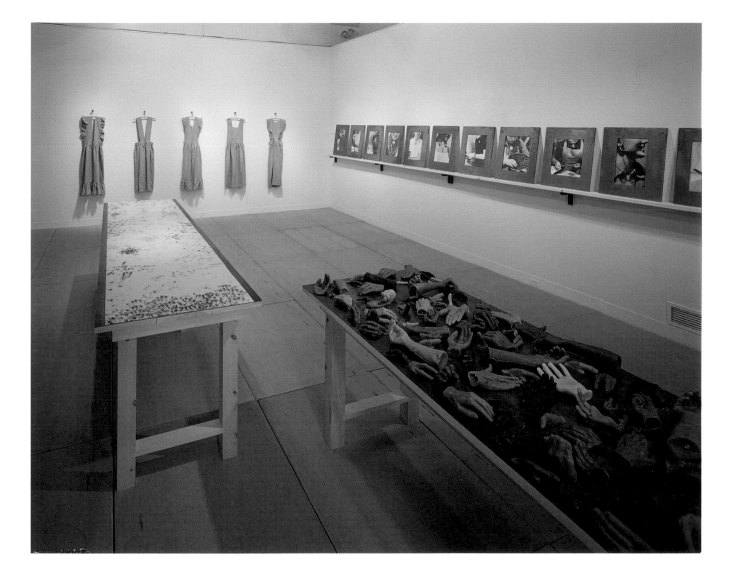

PLATE 1
Ellen Rothenberg
installation view
Beautiful Youth, 1995–99
mixed media

All plates courtesy of the artist.

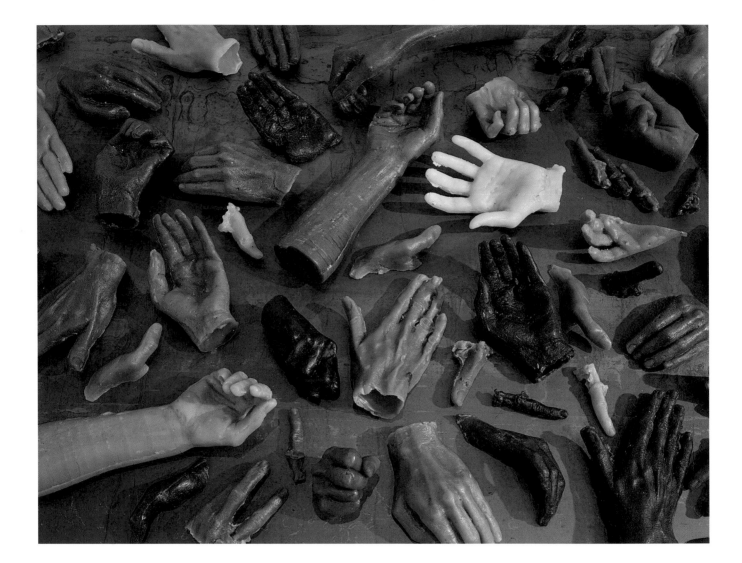

PLATE 2
Ellen Rothenberg
detail of hand fragments
Beautiful Youth, 1995–99
wax

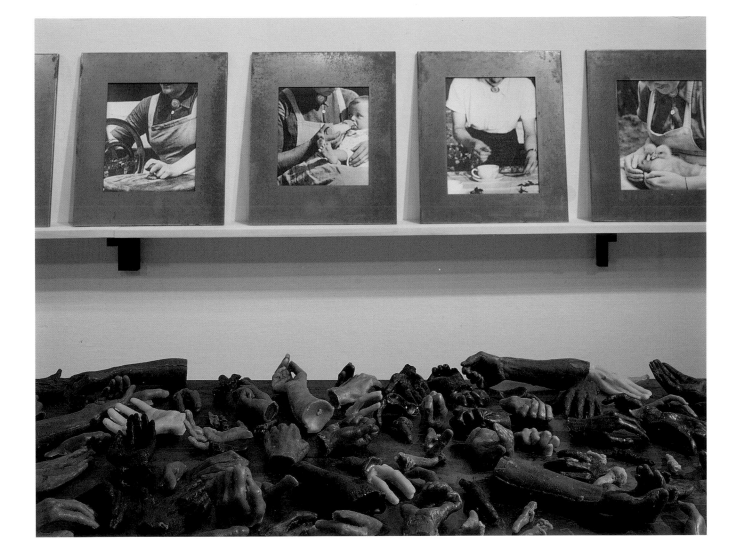

PLATE 3
Ellen Rothenberg
installation view
Beautiful Youth, 1995–99
mixed media

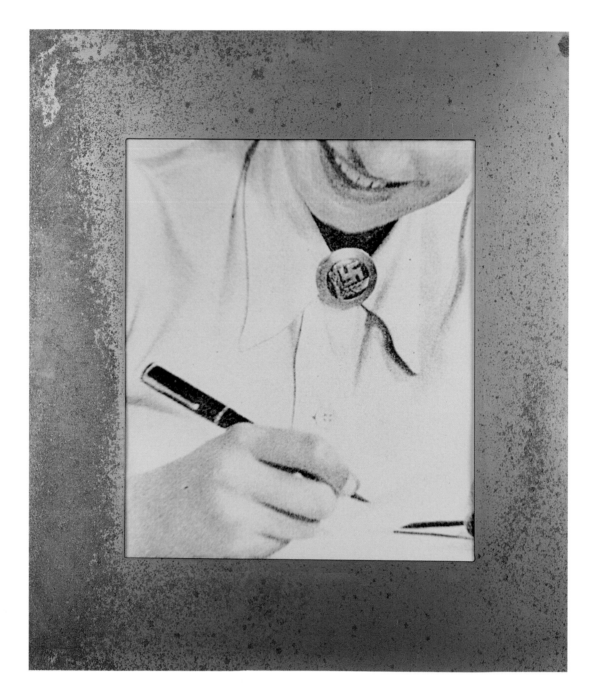

PLATE 4
Ellen Rothenberg
detail of installation
Beautiful Youth, 1995–99
photograph and steel frame
26 x 22 inches

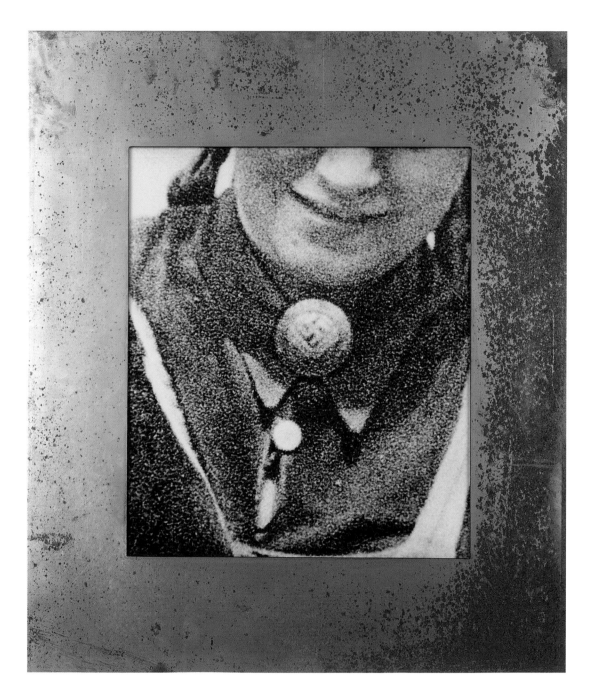

PLATE 5
Ellen Rothenberg
detail of installation
Beautiful Youth, 1995–99
photograph and steel frame
26 x 22 inches

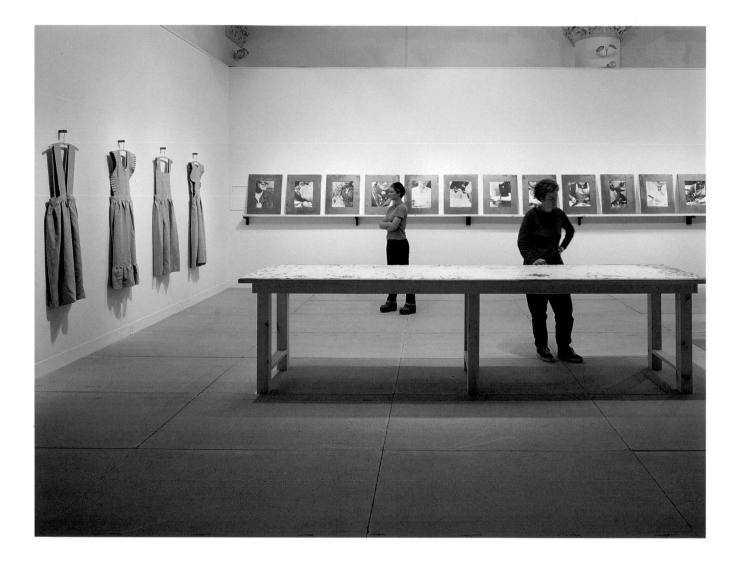

PLATE 6
Ellen Rothenberg
installation view
Beautiful Youth, 1995–99
mixed media

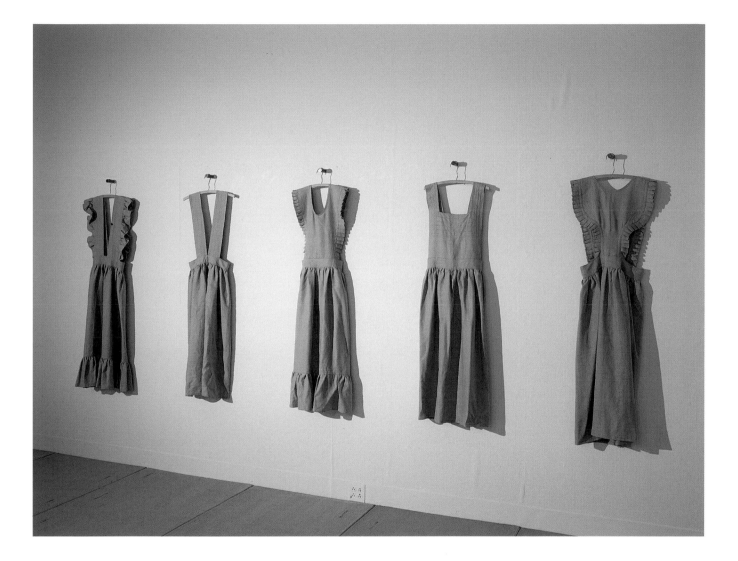

PLATE 7
Ellen Rothenberg
detail of aprons
Beautiful Youth, 1995–99
linen and wooden coat hangers on steel pegs

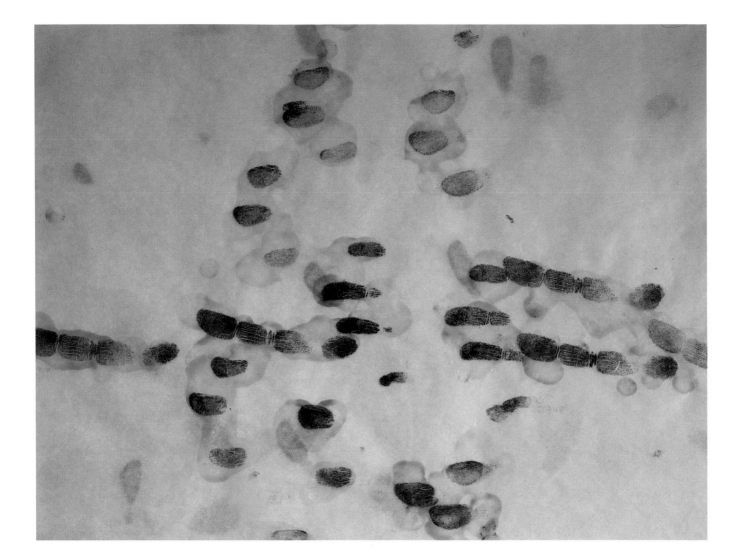

PLATE 8
Ellen Rothenberg
detail of fingerprints
Beautiful Youth, 1995–99
ink and beeswax on glassine

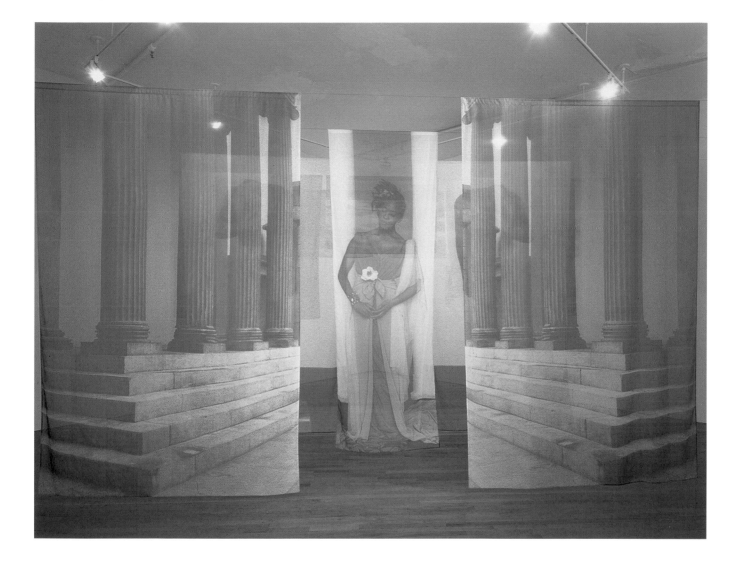

PLATE 9
Carrie Mae Weems
installation view
Ritual and Revolution, 1998
digitally printed muslin banners

All plates courtesy of the artist and P•P•O•W, New York.

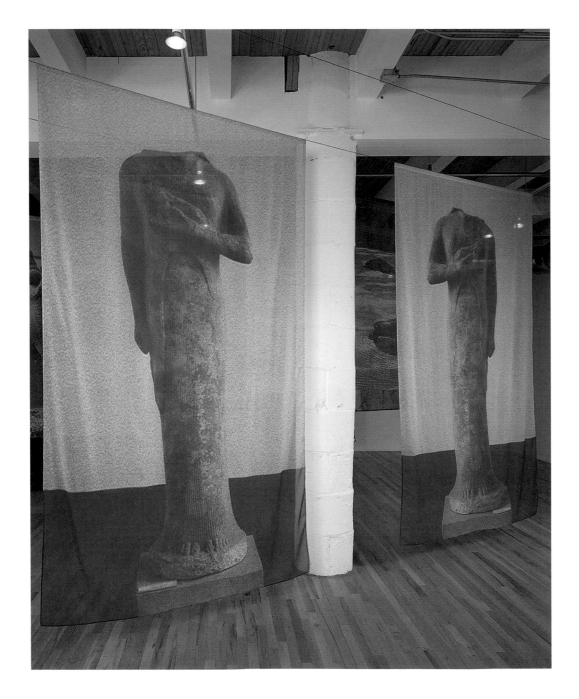

PLATE 10
Carrie Mae Weems
installation view
Ritual and Revolution, 1998
digital photographs on muslin, color pigment

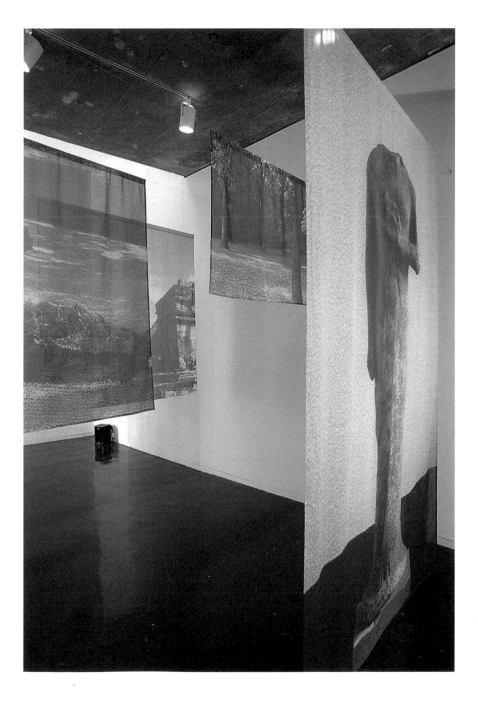

PLATE 11
Carrie Mae Weems
installation view
Ritual and Revolution, 1998
digitally printed muslin banners

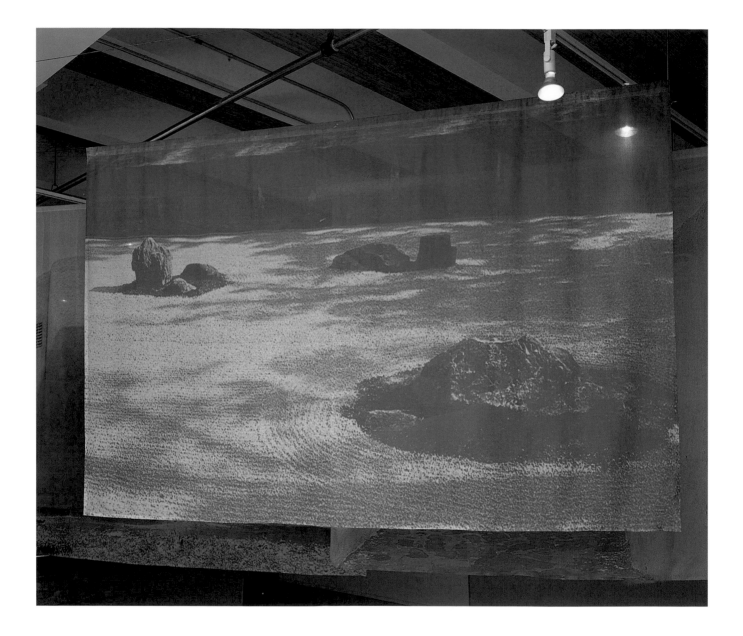

PLATE 12
Carrie Mae Weems
installation view
Ritual and Revolution, 1998
digitally printed muslin banners

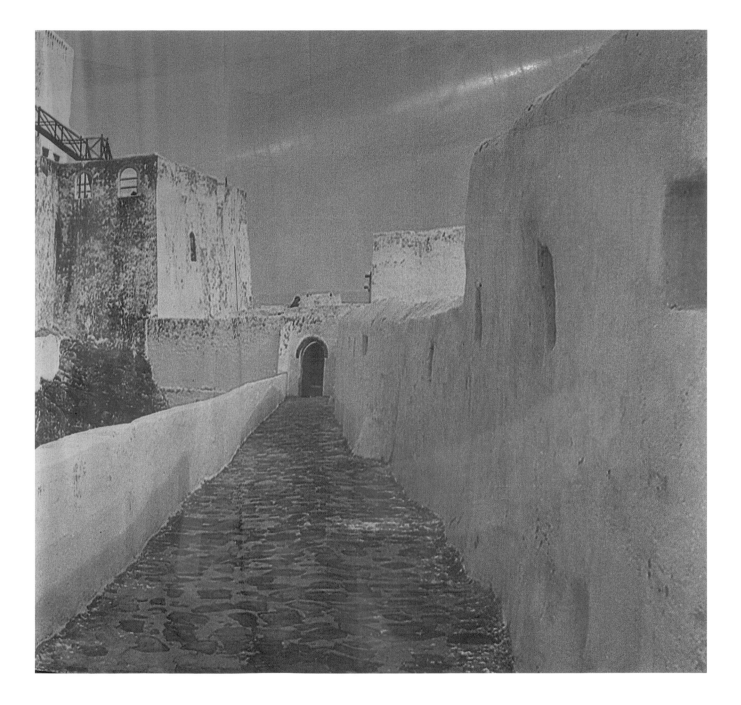

PLATE 13
Carrie Mae Weems
detail of installation
Ritual and Revolution, 1998
digitally printed muslin banner

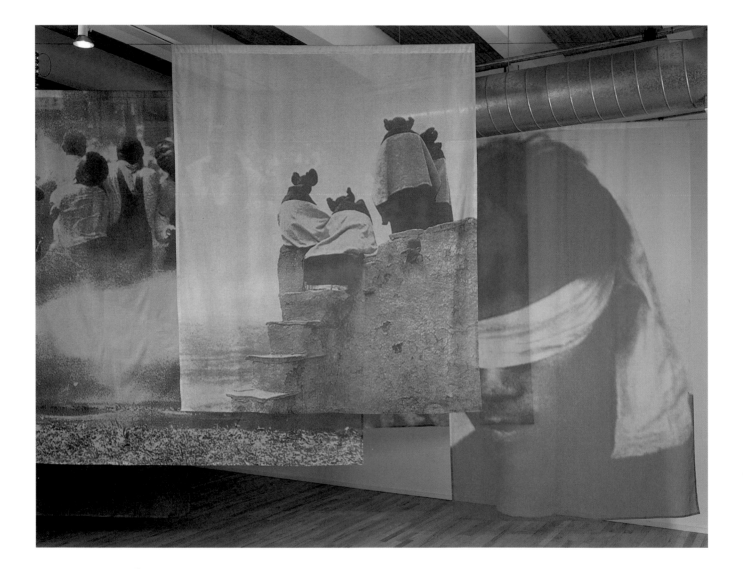

PLATE 14
Carrie Mae Weems
installation view
Ritual and Revolution, 1998
digitally printed muslin banners

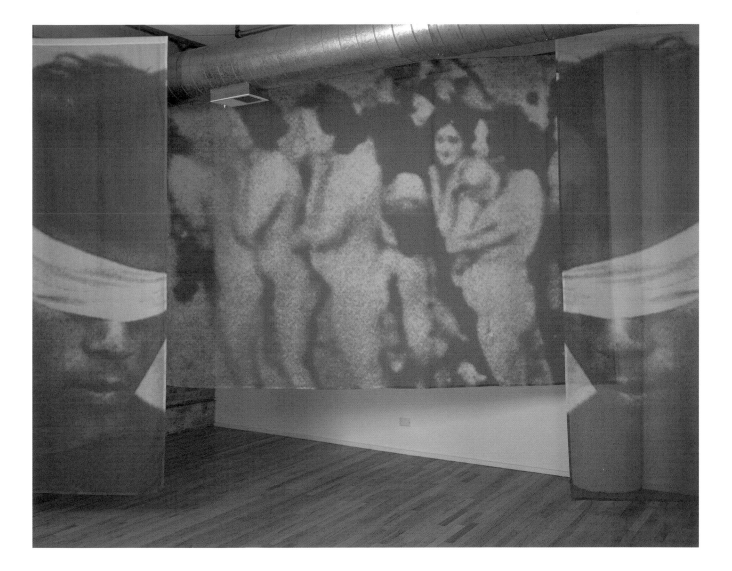

PLATE 15
Carrie Mae Weems
installation view
Ritual and Revolution, 1998
digitally printed muslin banners

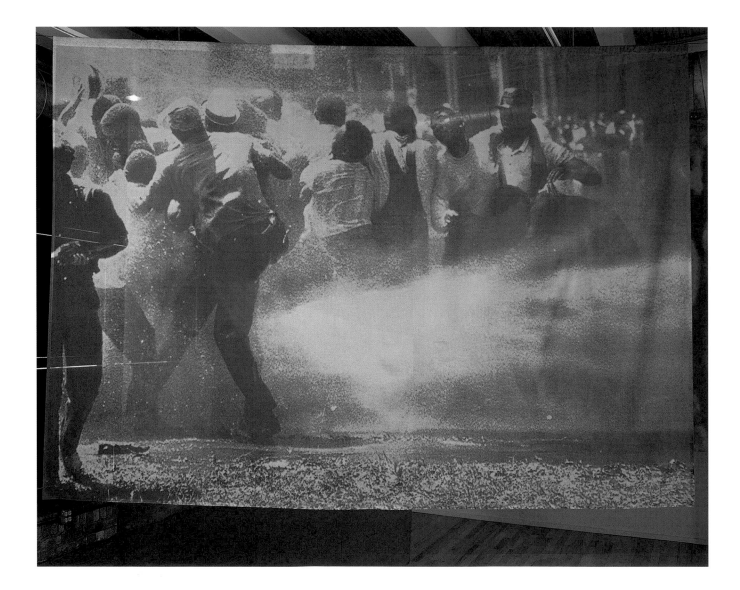

PLATE 16
Carrie Mae Weems
installation view
Ritual and Revolution, 1998
digital photographs on muslin, color pigment

Text for
Ritual and Revolution
CARRIE MAE WEEMS

Between the two worlds
I was with you
but as the wind on the Caspian Sea

I was with you
in the ancient ruins of time
you rode me hobby-horse
into the age of revolution

I was with you
when you stormed the Bastille &
The Winter Palace

I was with you
in the hideous mise en scene
of the Middle Passage
One potato, two potato, three potato, four
& in Ireland, too

I was with you
in the death camps
shaved head and all
beating the drummer's drum
shaking in my boots

I was with you
on the longest march
in Cuba & Timbukkta

I was with you
in Santiago
attempting to block
an assassin's bullet
and again in Harlem
cradling Malcolm to my bosom crying

Out of the shadows
from the edge of the new world
I saw your slow persistent emergence &
saw you spinning jenny's cotton into gold

Throughout the course of my existence
& I have been here always
I saw everlasting death
& the endless
weeping of women

I saw you and your father
your mother &
all your sisters
frozen static
in the autumn
of the patriarch

I saw your fear of pleasure
saw you mistaking sexuality for sensuality
& saw your body fragment into a zillion pieces

I saw men and women
locked into a futile struggle for power
& saw the declining significance of race

I saw your hands replaced
by inventions that left you idle
no laurel surrounding your name
no marker to mark
your existence

I saw nor heard any mention of
working class, you
& you said little
and did even less

In the halls of justice
I spied some of you robbing
the coffers of church & state
smashing the piggy-banks
using the shards
to pick your teeth

I too felt the allure
of temptation's temptress
and in no time flat
saw my own greed
my own corrupt hand
in the pot

Lost for a time
I saw you moving through
the shadowy corridors of
an ageless labyrinth
wondering when and where
it would all end

From the four corners of the world
I saw you bewildered, startled & stumbling
toward the next century
looking over your shoulder
with fingers crossed

From the ruins of what was and what will be
I saw your longing
felt your pain
and tried to comfort you

Afraid for you
I swooped down from my hiding place
kissed your brow
& left a bag of square shouldered courage
at your side

In the midst of the storm
trumpets blared
& from the top of Tatlin's monument
Stanley waved the white flag of surrender
Lorna turned her head
not once but twice
Bell hooked us all
intoning a constant refrain
GO ON
& dear Felix
beautiful and exhausted
blew us a long red beaded kiss
of farewell

In the twilight
coming on a day without end
Anna traced the tracks of your tears

& I could see again
the coming of Spring's hope
in the May flowers
of May Days
long forgotten

DATE D

Boston University

President: Jon Westling
Provost: Dennis D. Berkey

College of Arts and Sciences
Dean: Dennis D. Berkey
Chairman, Department of Art History: Jonathan Ribner

School for the Arts
Dean: Bruce MacCombie
Director, Visual Arts: Alston Purvis

Boston University Art Gallery
855 Commonwealth Avenue
Boston, Massachusetts 02215
617/353-4672

Director: John R. Stomberg

Curator: Karen E. Haas

Security: Evelyn Cohen

Gallery Assistants:
Catherine Blais, Rachel Hyman, Michelle Lamunière,
Julie Marchenko, Wendy Stein, Andrew Tosiello, and Francesca Tronchin

Catalogue Designer: Diana Parziale

Photographic Credits:
Figures 1, 4, 13,14, D. James Dee; figures 2, 3, 5, 6, 11, plates 1–3, 4–8, Bruce T. Martin;
figure 7, Ellen Rothenberg; figure 8, plate 4, Vernon Doucette, Boston University Photo Services;
figures 9, 10, Grace Moy; figure 12, C. M. Weems; figure 15, John Morris; plate 9, Adam Reich;
plates 10–16, Saverio Truglia, courtesy of Rhona Hoffman Gallery.

H9 444114